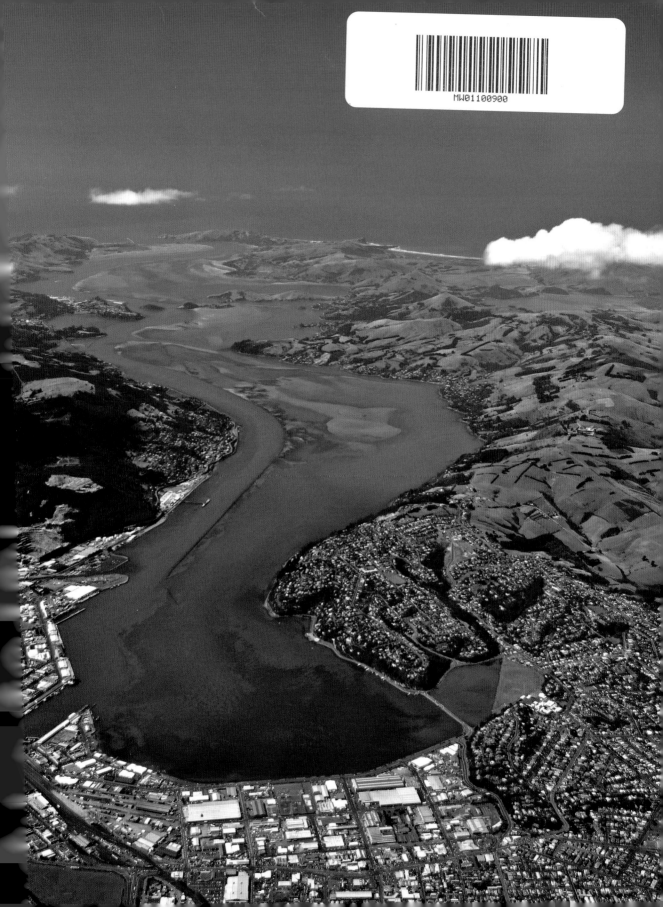

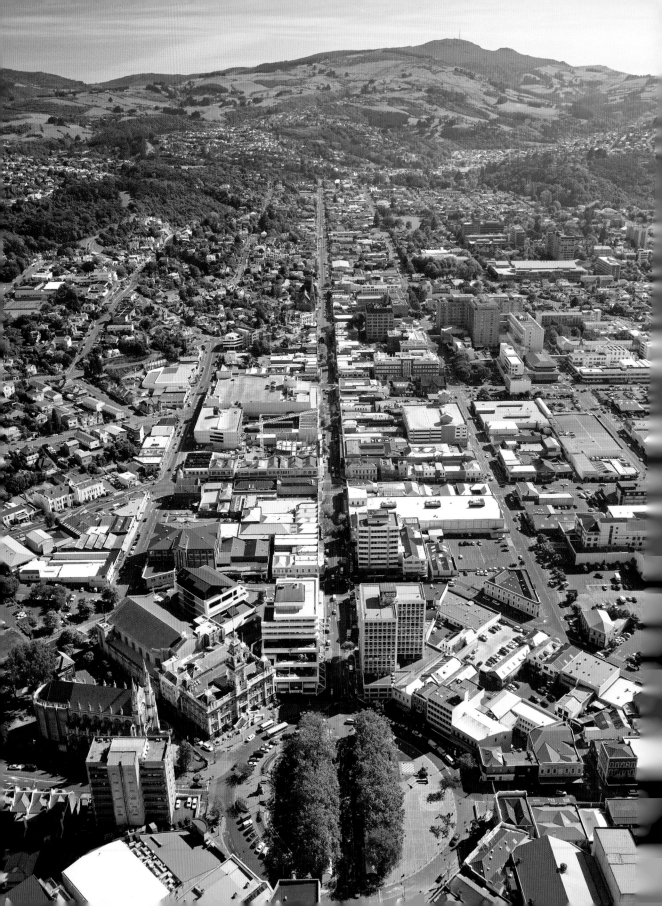

Opposite This aerial view shows the centre of Dunedin city, looking north towards Mount Cargill (680 metres). The central business district flanks the city's hub, the Octagon, in the foreground. The city is laid out on the flat, while the suburbs stretch up the surrounding hills, separated from the city by a green belt of native bush, part of which can be seen at the top left.

Right The Octagon's cafés and bars are busy day and night. The Regent Theatre, built in 1928, initially operated as a cinema but now plays host to local and visiting performances of theatre, ballet, film and music.

Below Historic buildings grace the upper Octagon: St Paul's Anglican Cathedral at left, and at right the Municipal Chambers building, which was completed in 1880 and subsequently much modified. In the foreground is a statue of Scotland's national poet, Robert Burns, reflecting Dunedin's strong Scottish heritage.

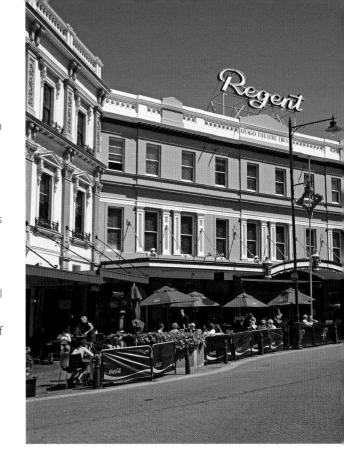

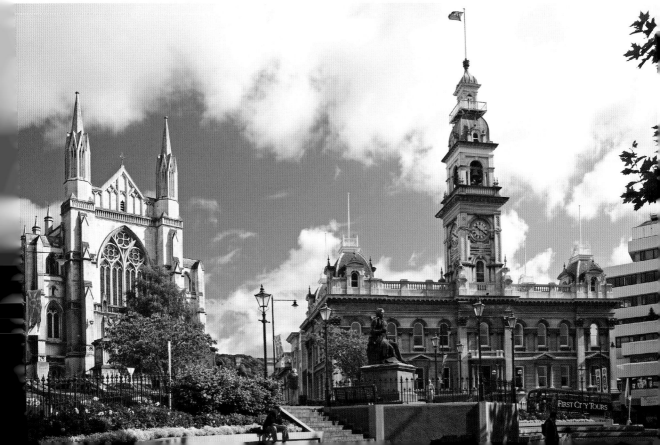

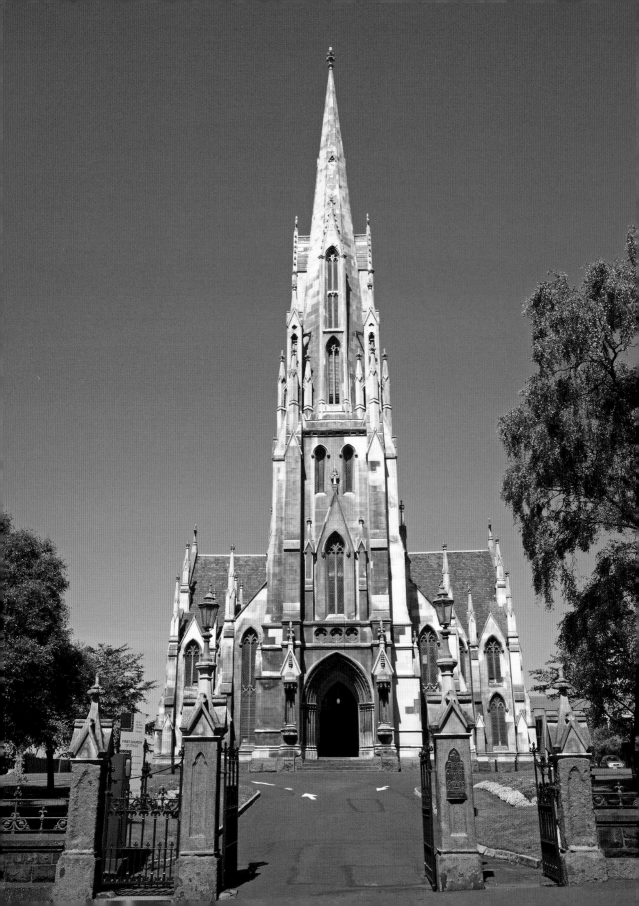

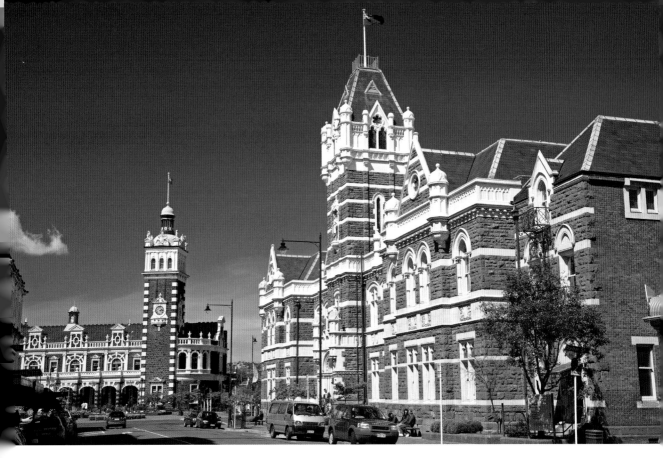

Opposite First Church, a magnificent stone church near the Octagon in Moray Place, was completed in 1873, replacing a wooden church on the site. It was built by Presbyterian settlers of the Free Church of Scotland, which had split from the church in their homeland. The 60-metre spire is visible from many parts of the city.

Above Historic buildings near the town centre include the Dunedin Railway Station (left) and the Law Courts (right). The latter was opened in 1902, and is made predominantly of Port Chalmers bluestone, with contrasting layers and window surrounds in Oamaru stone, a type of sandstone named after the north Otago town where it is quarried.

Right The stories of Dunedin and Otago's past are showcased at Toitū Otago Settlers Museum, which features fourteen themed galleries depicting the social history of the area, including a portrait gallery (right). The exhibitions include interactive displays and a database resource for people searching genealogy records. The museum combines Edwardian galleries built in 1907 and 1908 with a 1939 art deco building that was originally the bus station.

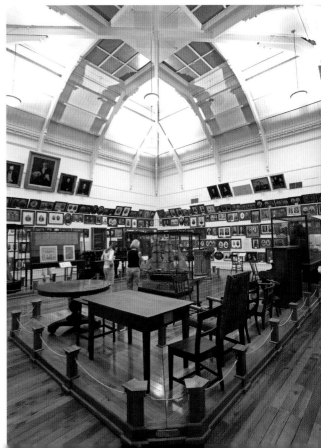

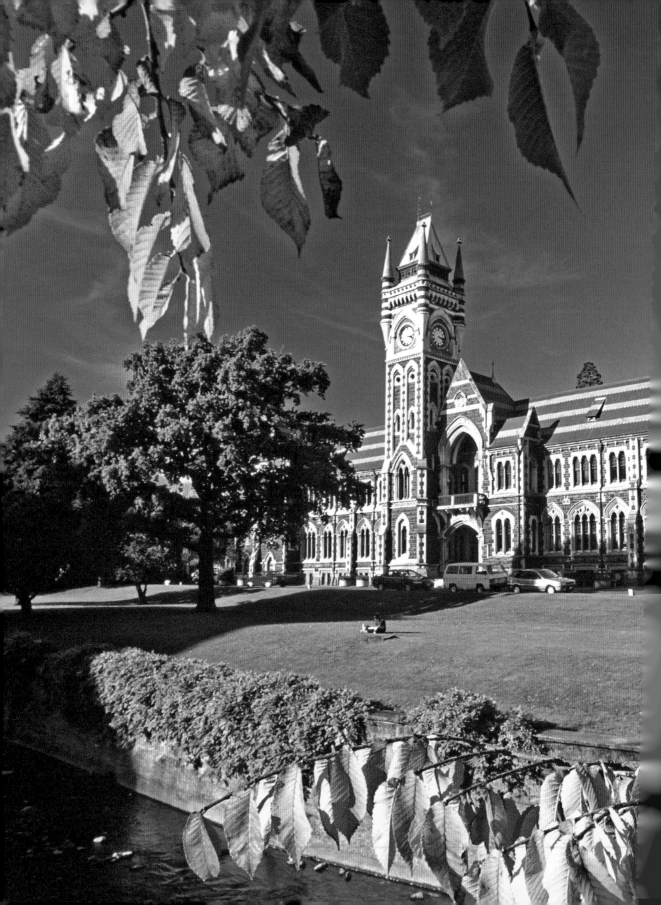

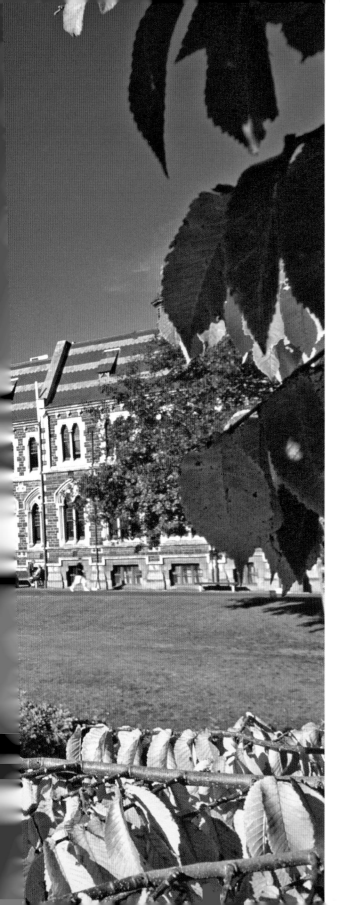

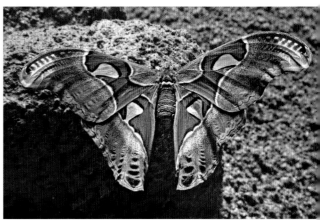

Opposite The clocktower building of the University of Otago, seen from across the Water of Leith. Founded in 1869, the university is New Zealand's oldest, and is best known for its medical school. Education in 19th-century Scotland was more accessible and of a higher standard than that in England, and settlers brought these values to Dunedin. The university has an international reputation for research and offers a wide range of courses. The 20,000 students ensure a lively youth culture, which includes music, art, film and a bustling café and pub scene.

Above One of the main attractions at the Otago Museum is the butterfly house, a tropical oasis where it is summer all year round. The museum's permanent displays are a good introduction to southern Maori history and Pacific peoples, and to New Zealand's natural history.

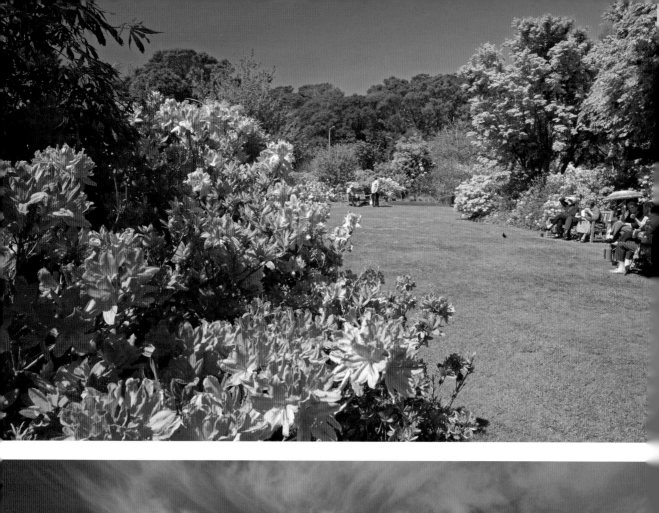
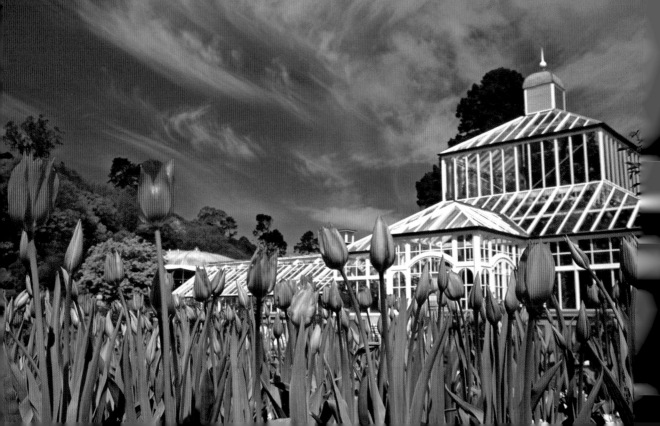

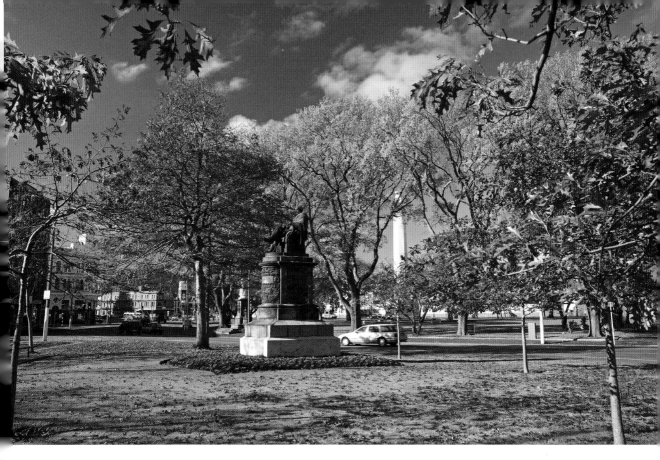

Opposite top In spring the azalea section of Dunedin Botanic Garden is a tranquil spot bursting with fresh colour. Azaleas are a type of rhododendron, a local favourite that is celebrated in the city's Rhododendron Festival in late October every year.

Opposite bottom Glasshouses at the Botanic Garden keep tropical plants and cactuses warm through the coldest of winter days. The 28-hectare garden features over 6800 plant species, and includes formal European and Japanese gardens, rock gardens and native plantings.

Above Queen's Gardens in autumn. The park's statues include one of Queen Victoria, and prominent late-19th-century Dunedin identity the Reverend Dr D. M. Stuart.

Right The Chinese Garden, near the Otago Settlers Museum, is a recent addition to Dunedin's attractions. Created in authentic Chinese style, the garden acknowledges both Dunedin's sister-city relationship with Shanghai and the Chinese settlers who began arriving in the city during the gold rushes of the 1860s.

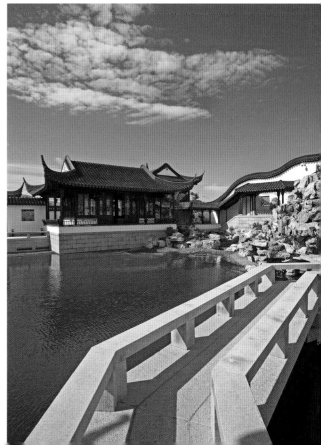

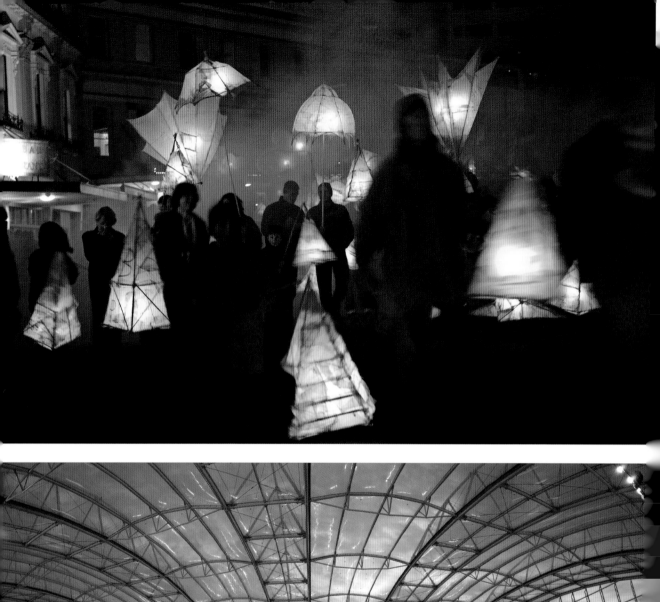
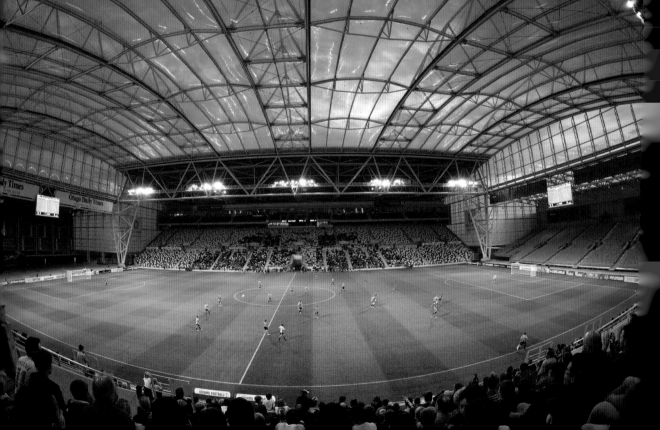

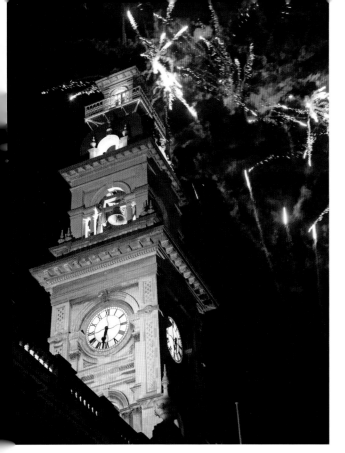

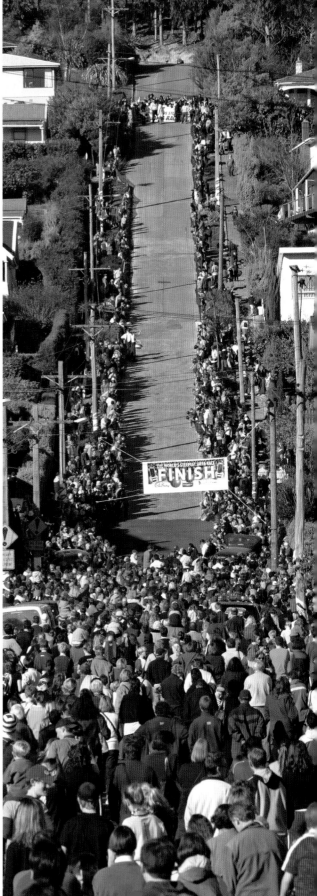

Opposite top Handmade candle lanterns are paraded around the Octagon as part of Dunedin's Midwinter Festival, helping to dispel the city's legendary winter chill. This event is one of many involving Dunedin's creative arts community.

Opposite bottom With a fully enclosed roof, Dunedin's Forsyth Barr Stadium is ideal for hosting a wide variety of events. There is seating for up to 30,000 fans attending rugby and soccer matches and in two main stands the seating can be removed to provide a venue for other functions such as concerts, equestrian events, freestyle motocross and trade fairs.

Above Festival fireworks light up the night sky above the Municipal Chambers clocktower in the Octagon.

Right Participants and spectators gather at the world's steepest street for the annual Jaffa Race. Numbered Cadbury's Jaffa sweets are rolled down Baldwin Street to raise money for charity. The street's average gradient is 1 in 3.41, and at its steepest it is 1 in 2.86.

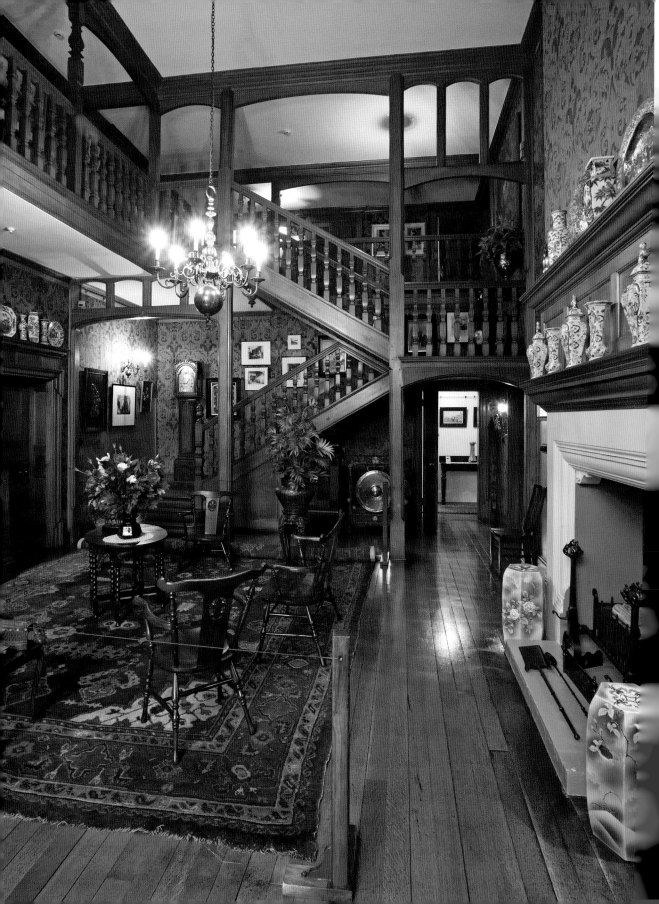

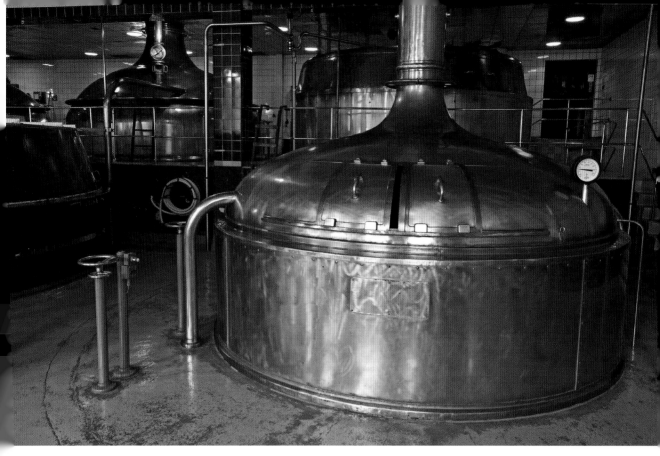

Opposite Olveston is a stately home built between 1904 and 1906 for a merchant, Mr Theomin, and his family. It is open daily for guided tours, offering an intimate glimpse into the life of a wealthy family in the Edwardian era. It is immaculately preserved inside and out, and full of period furniture, antiques and paintings.

Above The local brew in Dunedin comes from Speight's Brewery in Rattray Street, which has been making beer since 1876. Water to make the beer comes from a pure underground spring, and Speight's has installed a tap on the street for public access – to the water, not the beer! The brewery offers daily tours, outlining the history, showing the brewing process and pouring samples.

Right The chocolate waterfall, in a five-storey-high silo, is a memorable part of a tour of Cadbury World. The chocolate factory has its origins in a one-man biscuit-making business, Hudson's, founded in 1868 and later bought by Cadbury's. Now it is one of the city's biggest employers and makes about 85 per cent of New Zealand's chocolate.

Left Another example of Dunedin's heritage architecture, these faithfully maintained terrace houses are just above the Octagon in Stuart Street.

Below The Southern Cross Hotel in Princes Street offers top-quality accommodation as well as housing the Dunedin Casino. The corner building of the complex, opened in 1883 as the Grand Hotel, has retained many of its original features, notably the ornate ceilings. The new hotel name refers to the constellation that is one of the brightest in the southern hemisphere night sky, and is visible all year in New Zealand.

Opposite St Paul's Cathedral looms above the city nightscape of lower Stuart Street, just below the Octagon. Constructed between 1915 and 1919, this Anglican cathedral is a magnificent example of early 20th-century neo-gothic architecture. It is built almost entirely of Oamaru stone, and is unusual in New Zealand for its stone-vaulted nave. The stained-glass windows were designed and built in London, and donated by pioneer families of Dunedin.

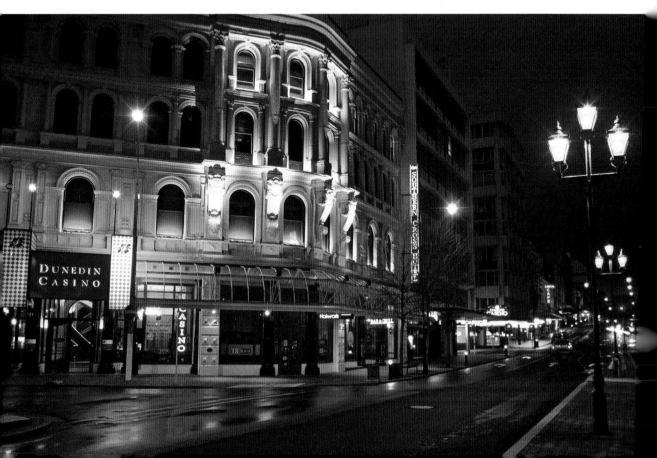

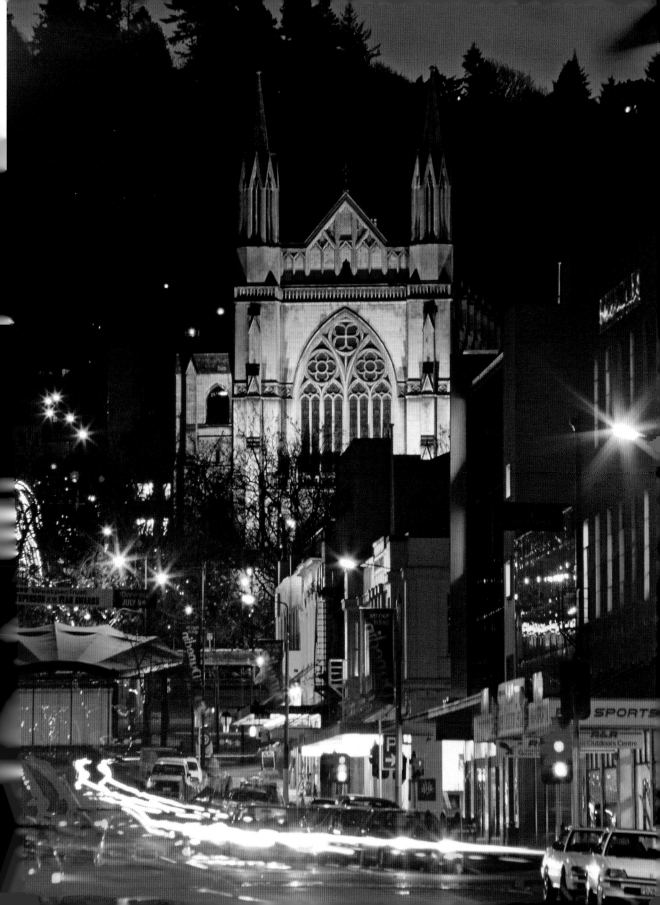

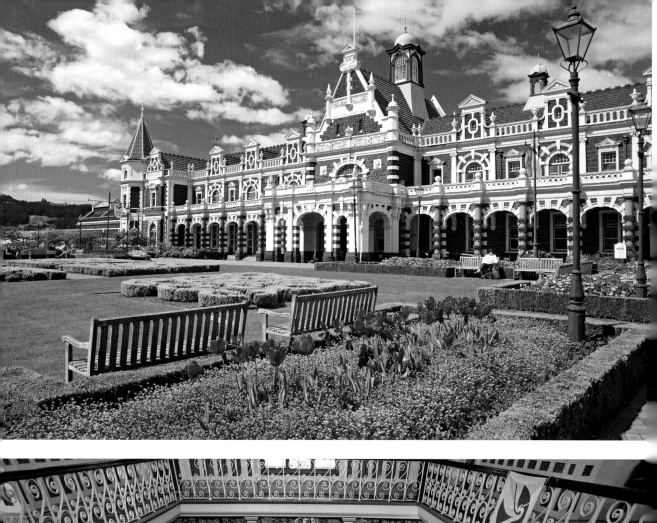
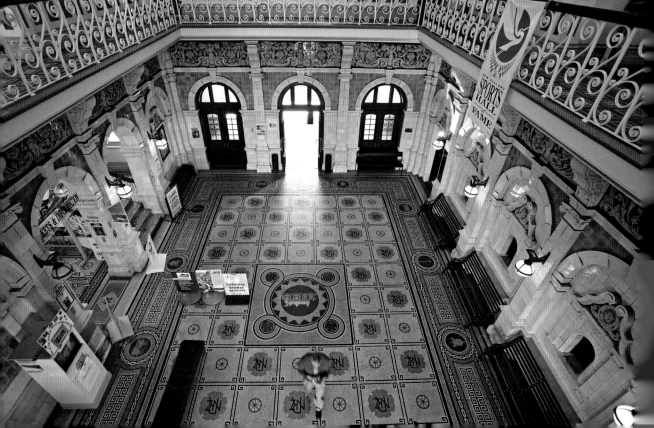

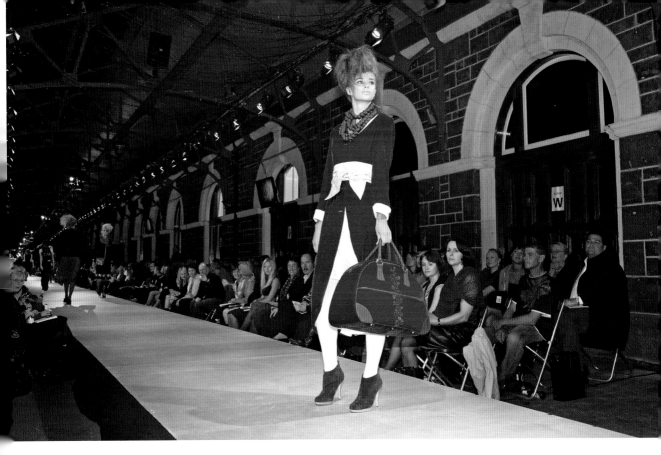

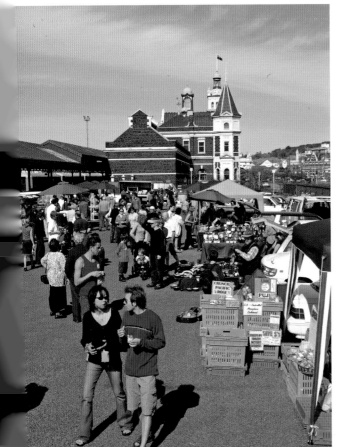

Opposite top Thought to be New Zealand's most photographed building, the Dunedin Railway Station is a fine example of Flemish Renaissance-style architecture. It was built between 1904 and 1906 using stone from Kokonga, near Ranfurly, with Oamaru stone for the facings and Aberdeen granite for the pillars.

Opposite bottom The station interior has an intricate mosaic floor and features a ceramic frieze and stained-glass windows with railway motifs.

Above A model shows off Tamsin Cooper designs at the annual 'id' fashion week. The catwalk, believed to be the longest in the world, runs the length of the Dunedin Railway Station platform. In recent years the city has blossomed as a centre of fashion design, encouraged by the School of Fashion at the Otago Polytechnic, and by the Dunedin Fashion Incubator.

Left On Saturday mornings up to 5000 shoppers flock to the railway station for the Otago Farmers' Market. Musicians entertain the crowds who come to sample the fresh local produce.

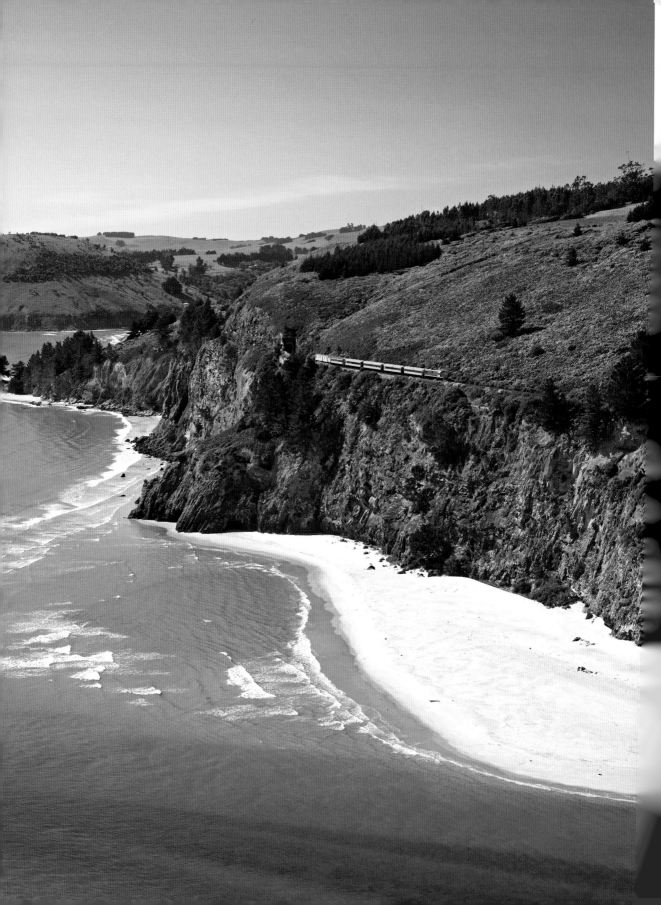

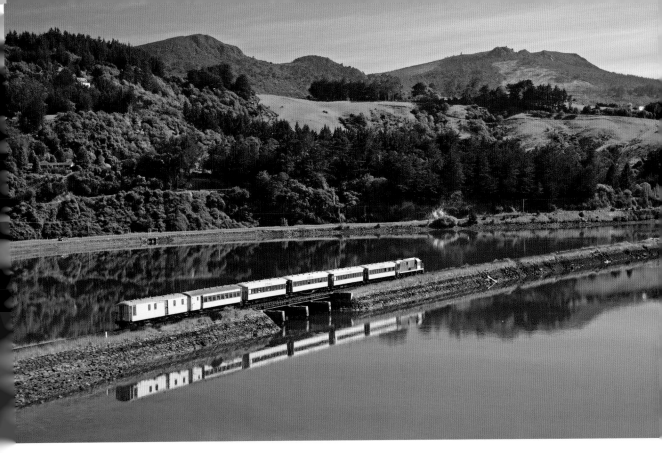

Opposite The Seasider train affords a stunning view from the top of the cliffs at Doctors Point, north of Dunedin. This tourist trip winds around the Otago Harbour, plunges into tunnels at Port Chalmers, and emerges at Purakaunui to descend the hill shown here, before continuing up the coast to Palmerston.

Above The Otago Harbour on a calm day mirrors the Seasider train.

Right Another very popular local train trip is on the Taieri Gorge train, which travels inland from Dunedin. The track follows the Taieri River up through a rugged gorge, crossing over a dozen viaducts, passing through 10 tunnels and reaching the rocky, dry, sheep-farming hill country of Central Otago. Visitors can make a half-day return trip, or stop at Middlemarch and venture further by cycling or walking the Otago Rail Trail.

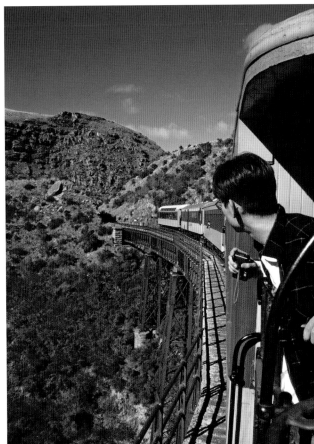

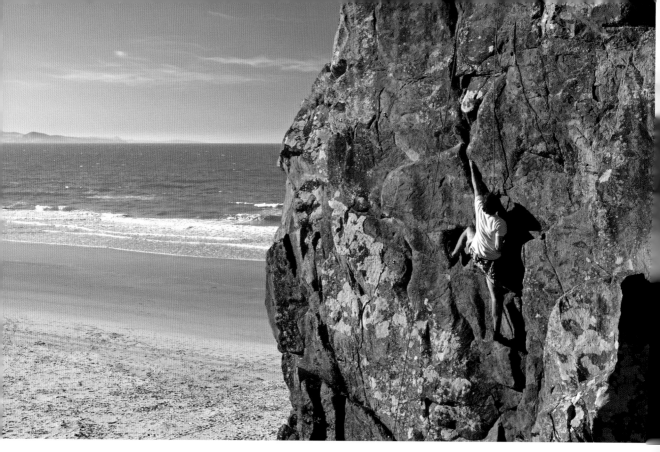

Above The coast north of Dunedin is full of natural beauty spots and opportunities for outdoor activities. The cliffs at Long Beach provide an ideal challenge for rock climbers.

Right Sea caves near Matanaka, north of Dunedin, can be accessed by boat at low tide only. Guided kayak tours based at Karitane leave from Waikouaiti Beach, paddling north to reach the caves.

Opposite The village of Purakaunui has long been a holiday getaway, and most of the dwellings are 'cribs' or holiday houses. Boat sheds ring the large tidal inlet. The headland in the middle distance is Mapoutahi, where once there was a Maori pa, or fortified settlement. Conflicts between rival Maori groups over 200 years ago led to a siege at the pa. Accounts vary as to whether just one man escaped, or a few people, via vine ladders down to the sea.

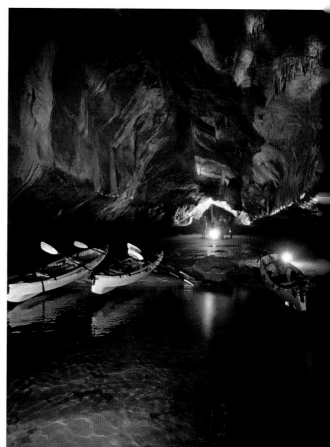

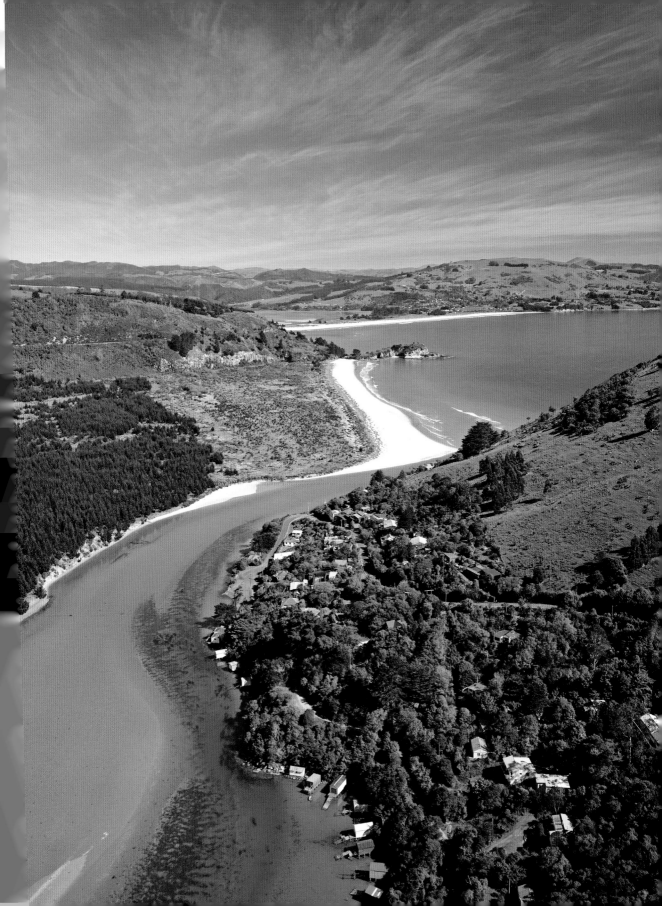

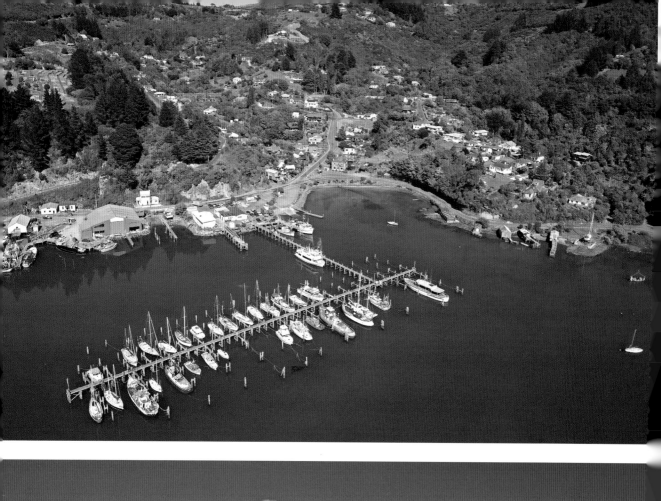

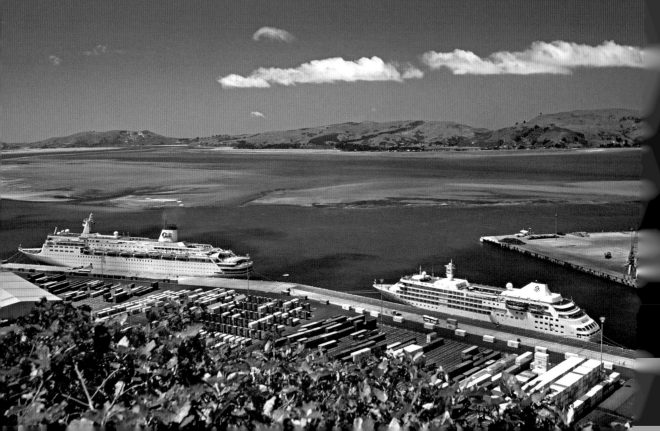

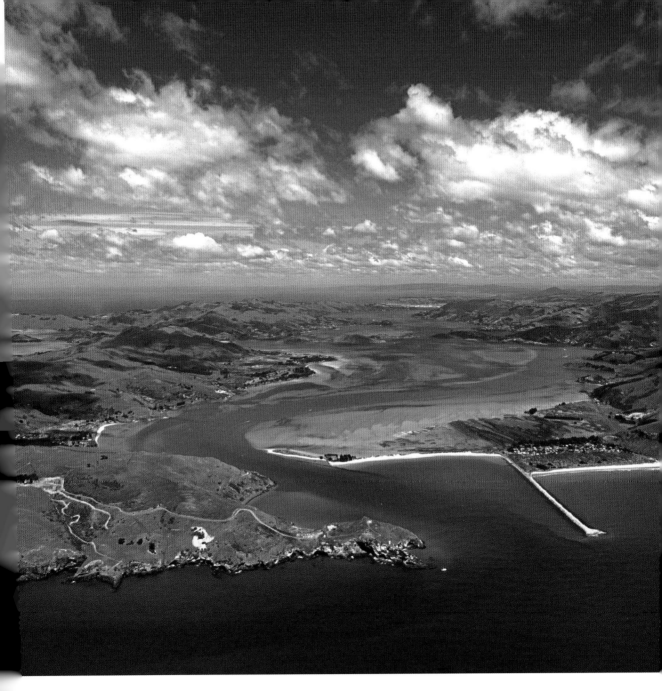

posite top Yachts and fishing boats are moored at
turesque Careys Bay, on the Otago Harbour just beyond
t Chalmers. Races are held on the harbour there annually.
e pub, which was built in 1874, is an ideal place from which
watch the changing moods of the harbour and the passing
ter traffic.

posite bottom Port Chalmers is one of New Zealand's
iest ports. It is a major export centre for primary
ducts such as logs, meat, fish, dairy products and apples.

Cruise ship visits to the port have increased in recent
years. Port Chalmers has a strong artistic community,
with several galleries along the main street.

Above Ships entering Otago Harbour pass by Aramoana
Beach on the far right, and sail between the mole, or
breakwater, and Taiaroa Head. They follow the regularly
dredged deepwater channel on the right-hand side of
the harbour, avoiding the sandbanks and shallow water
in the centre.

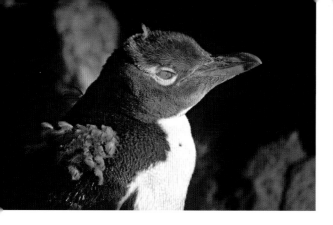

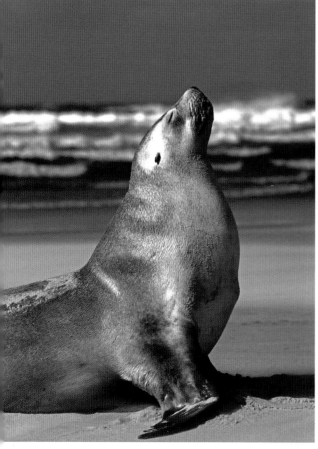

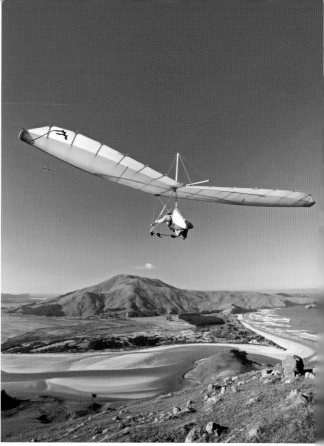

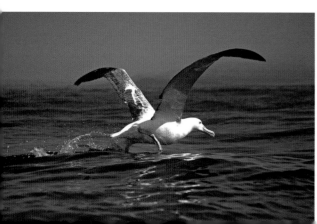

Left top New Zealand's own yellow-eyed penguin (hoiho) is one of the world's rarest penguins, with a population of around 5000. Conservation efforts have led to increased numbers on Otago Peninsula.

Left middle Once numerous, the New Zealand sea lion was hunted almost to extinction on the mainland before European settlement. In the late 20th century it began making a comeback on the peninsula.

Left bottom The royal albatross is the largest of its kind, with a wingspan of up to 3 metres. It can fly at speeds of up to 115 km/h. These birds spend most of their time at sea, and the world's only inhabited mainland breeding colony is Taiaroa Head, on the tip of Otago Peninsula.

Above A hang glider floats free above the peninsula, looking across Hoopers Inlet to Mt Charles and Allans Beach.

Opposite Visitors to Otago Peninsula can take guided tours to see penguins and albatrosses, and may also see seabirds, dolphins, whales, sea lions, elephant seals or leopard seals.

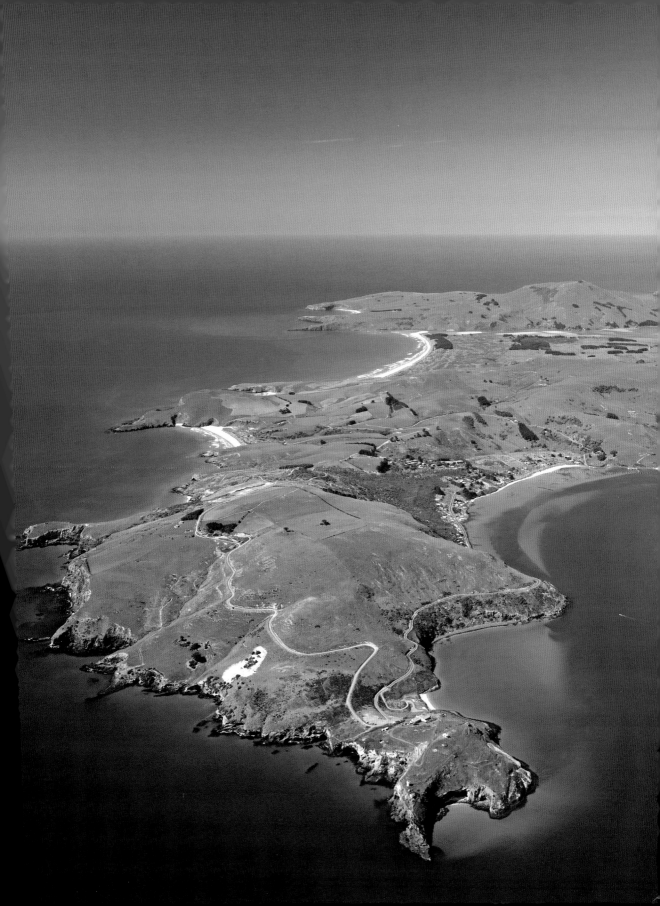

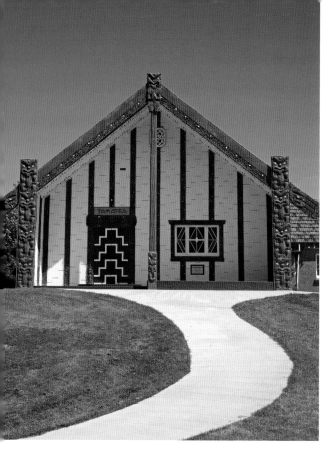

Above The wharenui, or Maori meeting house, at Otakou Marae on the Otago Peninsula looks similar to wharenui around the country. However, the poles and bargeboards, with figures representing ancestors, are made of concrete rather than the usual carved wood. Otakou was one of the places where the Treaty of Waitangi was signed in 1840, and remains an important centre for those of Kai Tahu descent.

Right Larnach Castle was built in a lavish style between 1871 and 1887 by William Larnach, one of New Zealand's early parliamentarians. Now it is a popular tourist attraction and venue for weddings and other functions. Harbour Cone is the long-dormant volcanic peak beyond the castle. Its Maori name, Hereweka, means 'trapping weka', referring to a flightless native bird that is no longer found in this area.

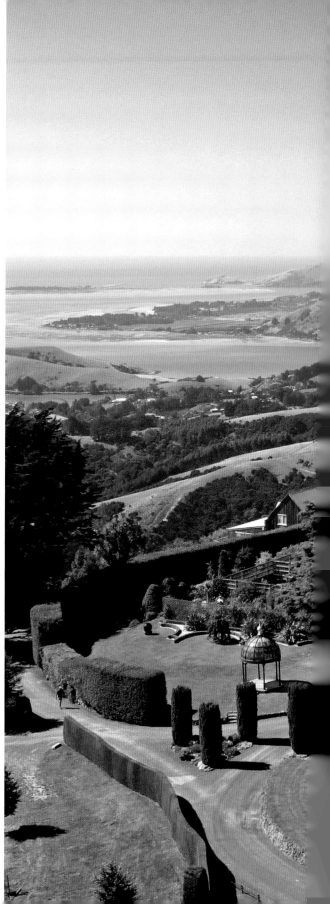

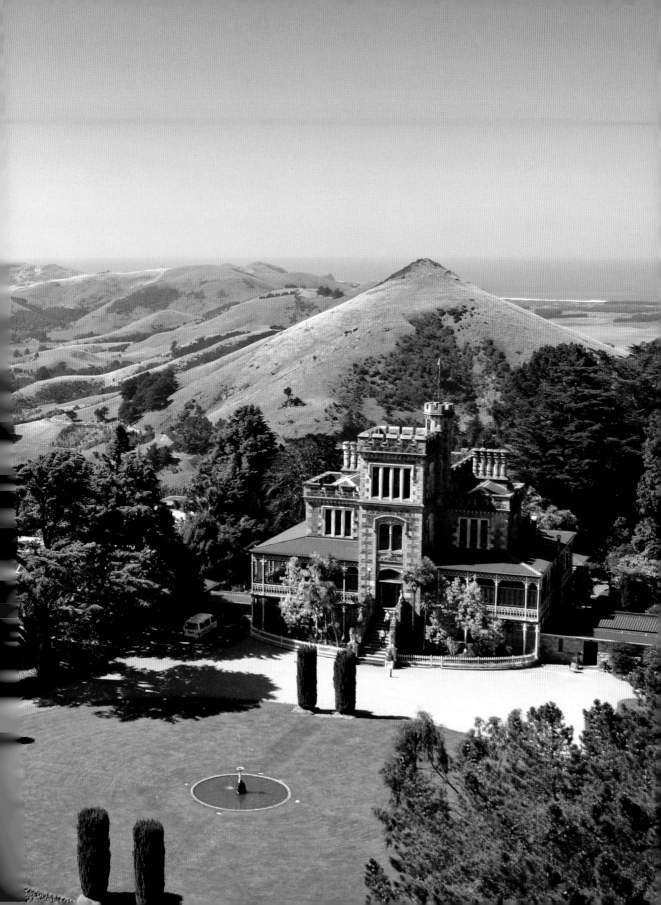

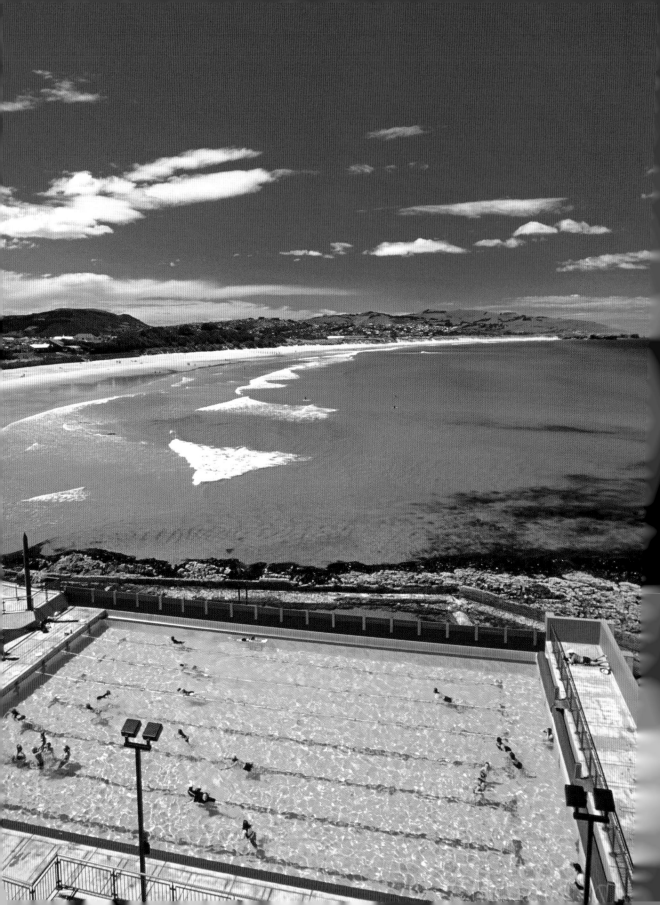

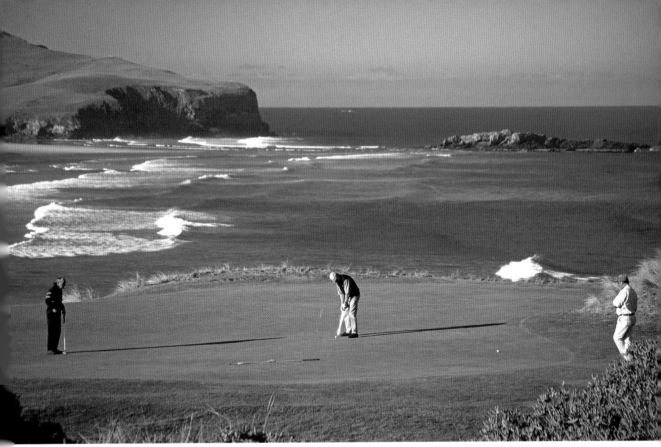

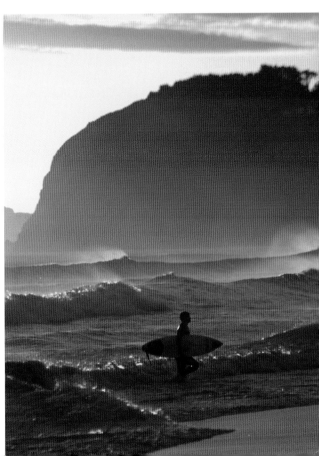

Opposite Open between October and March, the heated St Clair Salt Water Pool provides a safe swimming environment right next to St Clair Beach. The white-sand stretch beyond is Dunedin's most accessible and popular seaside spot, right on the city's southern doorstep. Three beaches are rolled into one: St Clair Beach at the left, then Middle Beach, and St Kilda in the distance.

Above No city with Scottish heritage would be complete without several golf courses. From Chisholm Park Golf Course, Smaills Beach can be seen in the background. In a southerly direction (to the right of the picture), the next major land mass is Antarctica, about 3500 kilometres away.

Right A surfer leaves the St Kilda Beach waves behind for the day. Surfers clad in wetsuits to keep out the cold of the Southern Pacific Ocean can be seen almost any time of day, most days of the year, in the breakers to the south of the city.

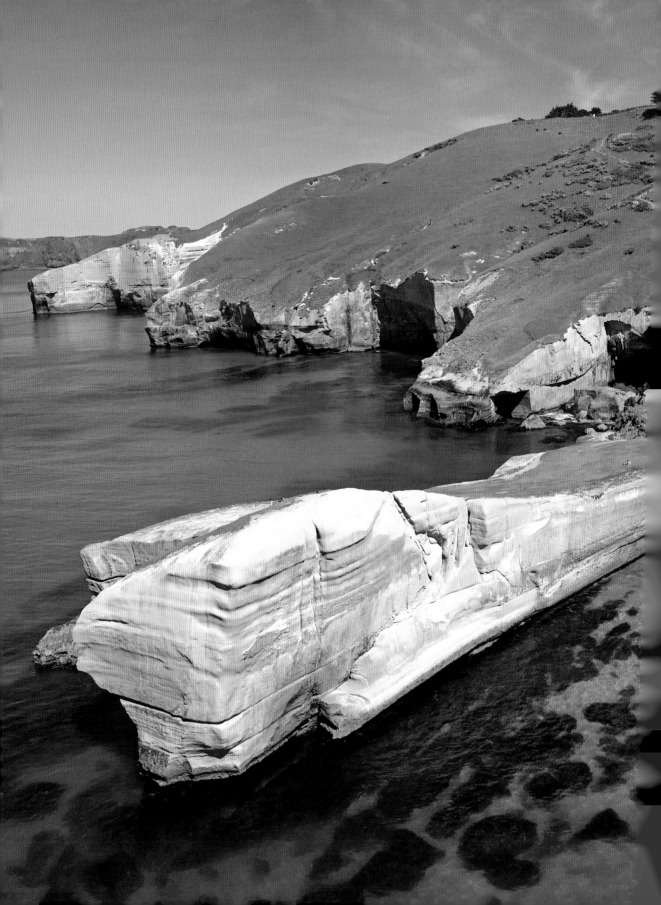

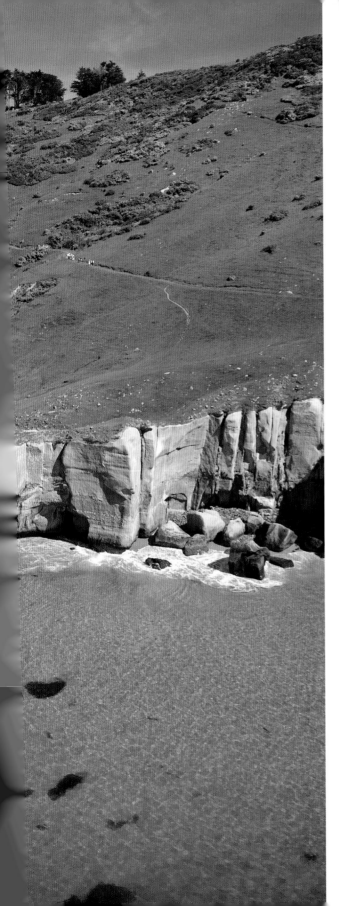

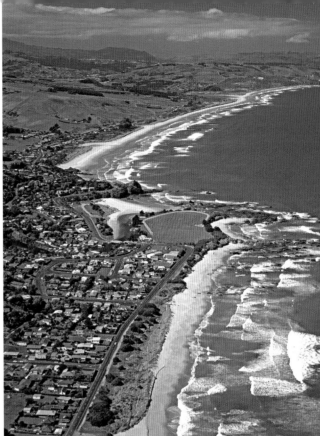

Left A spectacular headland juts out from fossil-rich sandstone cliffs on the coast south of Dunedin. There are only two ways to get to wild Tunnel Beach, at right – by boat or through a passage of steep steps cut into the rock. The tunnel was hand-carved in the 1870s at the behest of John Cargill, so his family could have private access to the beach near their home. A businessman and politician, Cargill was a son of one of the founding fathers of Dunedin, Captain William Cargill.

Above Brighton Beach, further down the south coast, is a popular family destination.

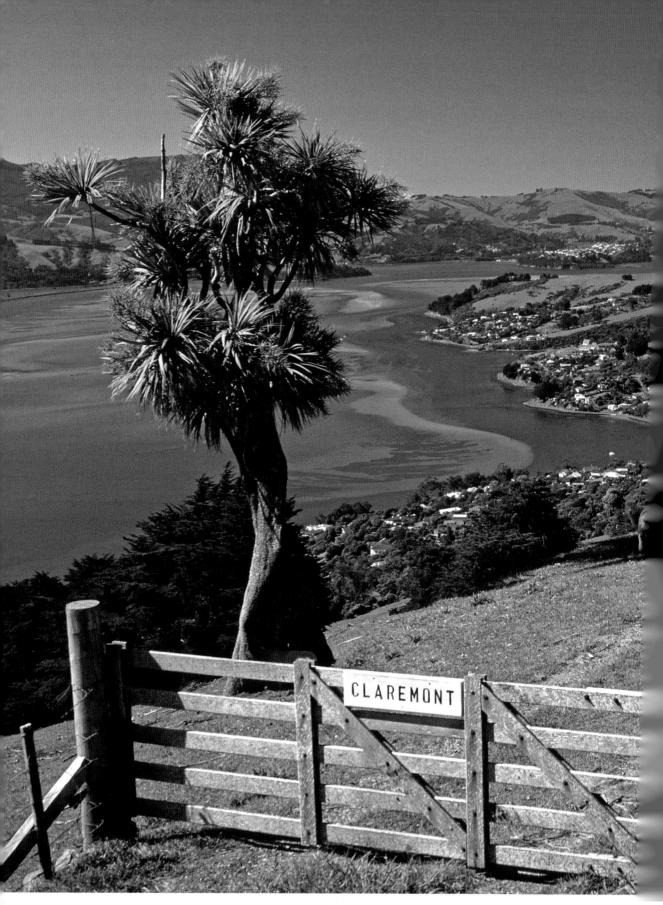